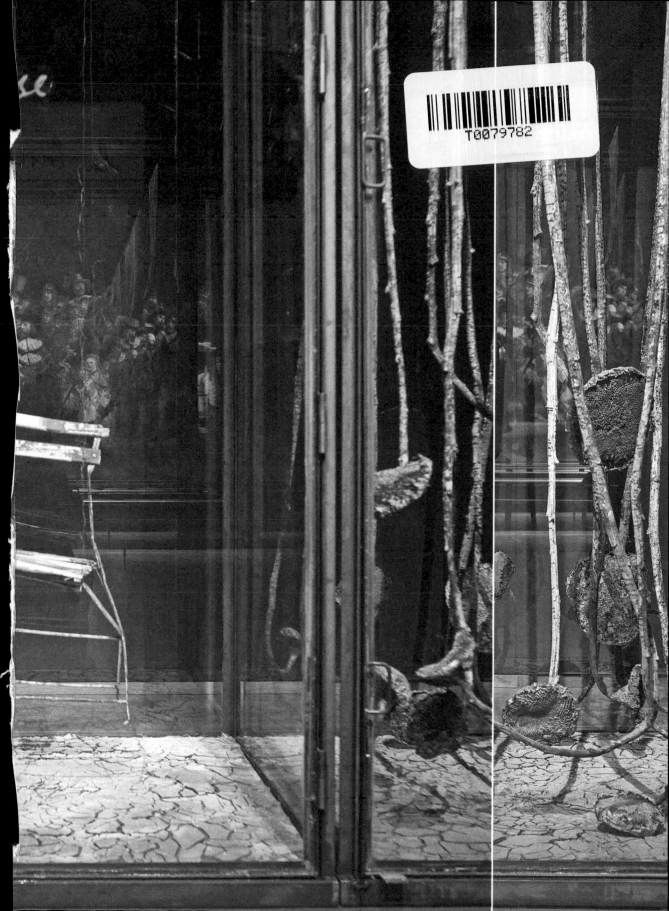

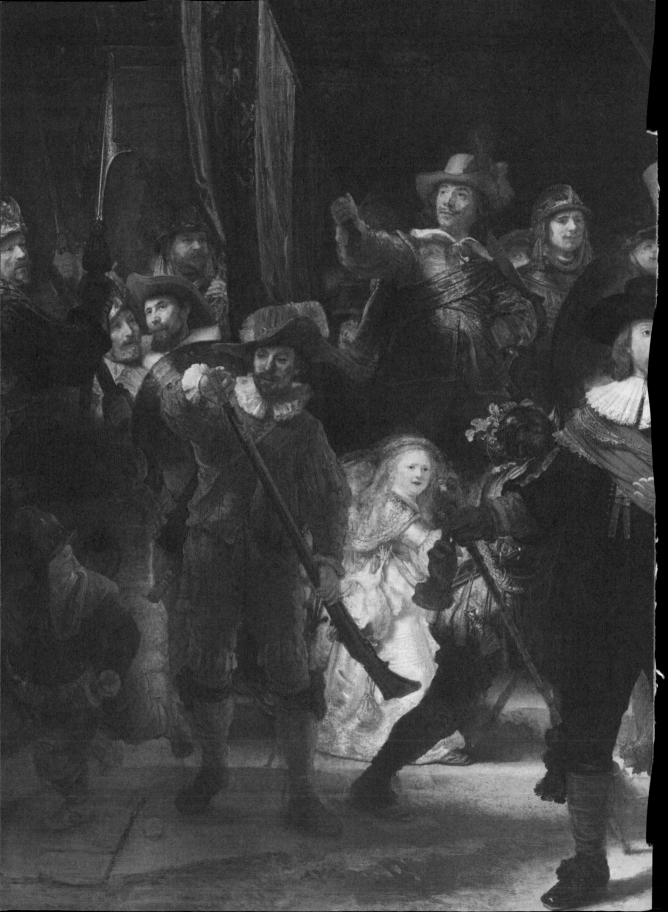

kiefer
rembra
kiefer

rudi fuchs

hirmer verlag

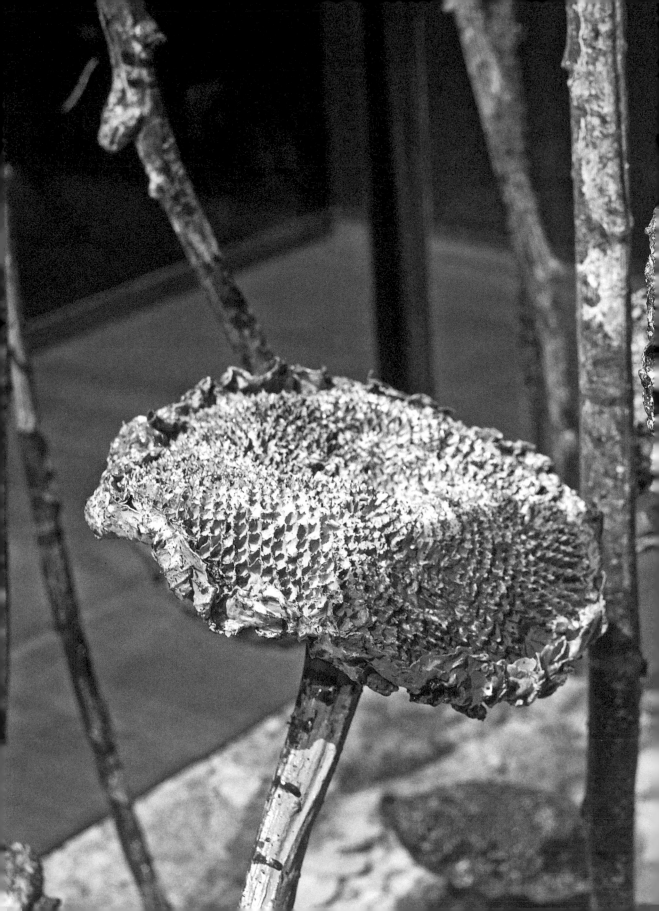

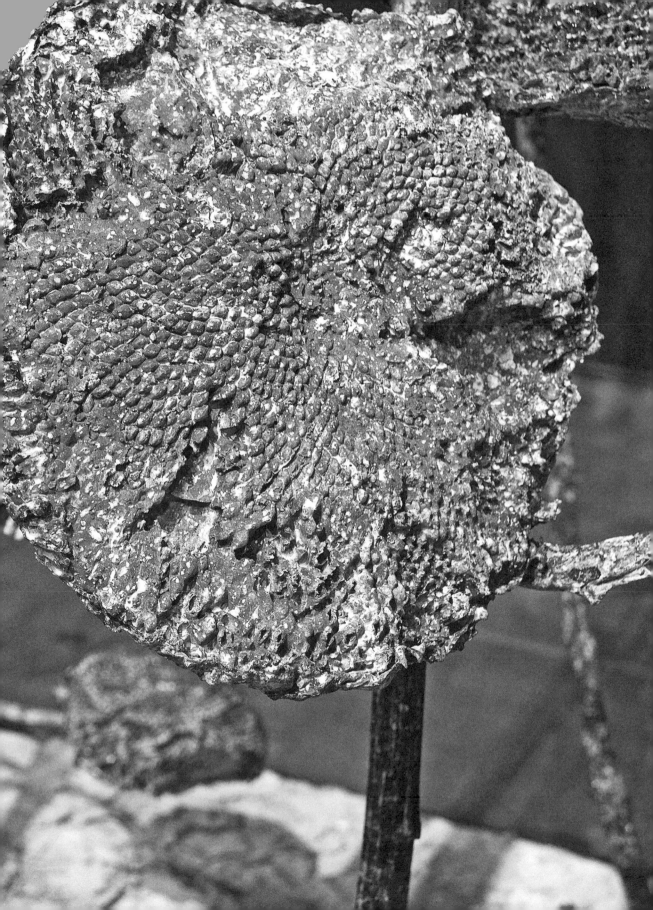

La Berceuse (2010), wie Anselm Kiefer seine Mise en Scène nennt, ist ein gleichsam geträumtes Werk. Zugleich ist es sonderbar regungslos. Da die Sonnenblumen sich kräuselnd herabhängen wie erstarrte Tränen, wirkt das Ensemble wie ein Lamento. Das verwundert nicht, denn es ist die Spiegelung eines anderen geträumten Werks, von dem van Gogh seinem Bruder Theo am 28. Januar 1889 in einem Brief aus Arles berichtet hatte, das jedoch nie ausgestellt wurde. Er hatte ein Porträt von Augustine Roulin gemalt, der Frau des Dorfbriefträgers, der sein Freund geworden war. An dem Bild hatte er gearbeitet, als er krank wurde, doch von der Berceuse, schrieb er, gäbe es jetzt schon zwei Fassungen. Wenige Tage zuvor, am 21. Januar, hatte van Gogh Paul Gauguin berichtet, wie er mit dem Bild von Madame Roulin weiter verfahren war, an dem er infolge seines Unglücks die Hände noch nicht ausgearbeitet hatte. Er schreibt, von Maler zu Maler: *Was die Anordnung der Farben betrifft: Das Rot steigert sich zu reinem Orange, das in den Fleischpartien noch einmal zu Chromgelb anschwillt und in Rosa übergeht und sich mit Veronesegrün und Olivgrün paart ... Und ich glaube, wenn man dieses Bild so in ein Fischerboot, selbst in ein Schiff der Islandfahrer, hängte, würden manche darin die Wiegerin erkennen.*[1] *Ach, lieber Freund, die Malerei zu dem machen, was die Musik von Berlioz und Wagner bereits für uns war ... eine Kunst, die traurigen Herzen Trost spendet! (...) In meiner Geistesverwirrung oder Nervenkrankheit oder meinem Wahnsinn, ich weiß nicht recht, wie ich es sagen oder nennen soll, haben meine Gedanken so viele Meere befahren ... und mir scheint, ich habe dabei ein altes Wiegenlied gesungen und dabei an das gedacht, was die Frau sang, die die Seeleute wiegte und das ich, bevor ich krank wurde, in einer Farbkomposition auszudrücken versucht habe.* Die Farbkompositionen, das sind die berühmten Sonnenblumen in einer Vase vor einem intensiven hellen Hintergrund, einem hellen Blaugrün oder Gelb, die ihn seit dem Sommer (als sie blühten) beschäftigt hatten.

In diesem Zustand, den er abwechselnd seine *Krankheit* nennt oder *Geistesverwirrung* oder auch sein *Unglück*, arbeitet Vincent einmal an der Berceuse und dann wieder an Sonnenblumen in einer Vase.[2] Bald stimmen diese beiden Sujets derart überein, dass ihm die Idee kam, sie zu einem Triptychon zu verbinden. Es würde, schrieb er Theo am 28. Januar, ein besonders trostvolles Bild werden, *vor dem die Seeleute, diese Kinder und Märtyrer zugleich, wenn sie es in der Kabine eines Islandfischerbootes sähen, ein Gefühl verspürten, als würden sie eingewiegt, als hörten sie wieder ihr eigenes Wiegenlied.* Damit ist auch das leise, singende Gefühl ausgedrückt, das diese Bilder durchwebt. In seinem Brief an Gauguin erzählt er auch, Roulin habe eines Abends, als er bei ihm zu Besuch gewesen sei, seiner kleinen Tochter etwas vorgesungen. Dabei *bekam seine Stimme ein eigenartiges Timbre, in dem etwas von der Stimme einer Wiegerin oder einer traurigen Amme lag, und danach einen bronzenen Klang wie von einem französischen Jagdhorn.* Unverkennbar lebte van Gogh in Arles in einem Zustand ständiger Wehmut. Vielleicht sollten diese intensiven Bilder ihm auch in seiner Einsamkeit Gesellschaft leisten und der eigenen Verwirrung Trost bieten.

Die Wärme der Farbe war, ebenso wie Musik, ein heilsamer Balsam. Über eine Vase mit Sonnenblumen schreibt er am 22. Januar 1889 an seinen Freund Arnold Koning: *Gemalt mit drei Chromgelbtönen, Ockergelb und Veronesegrün und sonst nichts. Auch durch die Wirkung der sämigen Farbe leuchten sie viel heller als sich in Worten sagen lässt.* Im selben Brief spricht er von der Berceuse: *Eine Frau in Grün (Büste Olivgrün und der Rock ein bleiches Veronesegrün).* Und dann: *Das

1
Sie hatten gemeinsam einen neuen Roman gelesen: Pierre Loti, *Pêcheur d'Islande*, Paris: 1886. Während die Fischer in der Kajüte verträumt auf ein Andachtsbild an der Wand schauten, fühlten sie die ruhige Dünung des Meeres, die ihr Schiff trug, und erinnerten sich daran, wie sie als kleine Kinder von ihrer Mutter gewiegt wurden.

2
Sein Geisteszustand war so labil gewesen, dass er am Abend des 23. Dezember 1888 ein Stück seines rechten Ohrs abgeschnitten hatte. Später in der Nacht war er, durch Blutverlust halb bewusstlos, vom Briefträger Roulin gefunden und ins Krankenhaus gebracht worden.

Haar ist ganz und gar orange und geflochten. Durch die kraftvolle Art mit den kurzen Strichen, in der sowohl das gekämmte Haar als auch die sich kräuselnden Blumen gemalt sind, erscheint ihre Form wie aus derselben Substanz und von demselben Gewicht. Und dann sieht ein Maler, dass etwas in seinen Werken vor sich geht, wenn er sie, fasziniert wie Vincent (selbst auch rothaarig), ununterbrochen anschaut und Dinge plötzlich eins werden. Dann, vor allem, wenn man selbst etwas fiebrig ist, fangen sie plötzlich an sich zu bewegen, werden sie unruhig. *Eine grüngekleidete Frau mit gelbrotem Haar gegen einen grünen Hintergrund mit rosa Blumen,* schreibt er Theo begeistert, (…) *Ich stelle mir diese Bilder zwischen den Sonnenblumenbildern vor, die auf diese Art zu beiden Seiten Fackeln oder Kandelaber in gleicher Größe bilden.* Welch meisterhafte Mise en Scène: Gemälde, die Licht spenden.

Im Mai 1889, als er sich im Hospital Saint-Rémy aufhält, scheint sich die Möglichkeit aufzutun, in Paris ein paar Bilder auszustellen. Weshalb dann nicht diese, endlich, schreibt er Theo. Er hat inzwischen vier Wiegerinnen und noch mehr Sonnenblumen. In seinem Brief skizziert er kurz: *Weißt Du, wenn du sie so anordnest, dass die „Berceuse" in die Mitte kommt und die beiden Sonnenblumen rechts und links davon, so bilden sie gewissermaßen ein Triptychon. Dann kommen die gelben und orange Töne des Kopfes durch die Nachbarschaft der beiden Flügelbilder leuchtender heraus. Und dann wirst Du verstehen (…) dass mir der Gedanke kam, eine Dekoration für die Rückwand einer Schiffskabine zu machen.* Gut ein Jahr später starb er, so früh in seinem schweren Leben, dass sein ganzes Œuvre eine traurige Elegie geworden ist.

Anselm Kiefers Version von *La Berceuse* besteht aus drei separaten, dicht nebeneinander stehenden Vitrinen aus Eisenrippen und klarem Glas. Ihre Standflächer messen 150 x 150 Zentimeter und sie sind etwa vier Meter hoch. Auf dem Boden liegt eine Schicht gebrannten Lehms, sandfarben, geborsten wie vertrocknete Erde. Von den geschlossenen Decken der linken und der rechten Vitrine hängen knorrige Stängel verblühter Sonnenblumen nach unten, deren Blüten sich – wegen der Umkehrung – bizarr nach oben kräuseln. Die Sonnenblumen sind mit Harz präpariert, das hier und da etwas glitzert. Mitten in der mittleren Vitrine hängt ein rostiger, abgeblätterter eiserner Klappstuhl, befestigt an Eisendraht, so schief verbogen, als sei er unter einem Gewicht zusammengebrochen. Quer über die vordere Glasscheibe der mittleren Vitrine steht mit schwarzer Ölkreide in der Handschrift des Malers *la berceuse* geschrieben. Die sonderbare Verwandtschaft dieser Mise en Scène mit van Goghs Gemälde müssen wir deshalb ernst nehmen. Als erstes fällt auf, dass die Frau verschwunden ist. Der leichte Stuhl (anders als der kräftige Holzstuhl mit gebogener Lehne auf van Goghs Bild) ist allerdings noch vorhanden. Er schwebt dort – etwas schief – dicht über der dürren Erde wie eine Schaukel. Wenn ich länger hinschaue, scheint er sich noch zu bewegen, unmerklich fast, als wäre gerade eben jemand daraus aufgestanden. Das ist in diesem Werk, genau in seiner Mitte, das epische Geschehen. Deshalb sind die Vitrinen so hoch: Sie sollen diesem rätselhaften Verschwinden im wahrsten Sinne des Wortes Raum geben. Ebenfalls verschwunden, verblichen und erloschen sind die vollen, strahlenden Farben, die van Gogh in seinem Triptychon (wie Lampen oder Kandelaber) entzünden wollte. Dies spürt man besser, denke ich, wenn man die Vitrinen im bleichen Lampenlicht des Ateliers sieht, wo sie entstanden sind. In diesem Licht, das zugleich kahl ist, neigen die Farben von Stuhl, Sonnenblume und vertrocknetem Lehm schnell zum Grau. Was in dieser Fast-Monochromie

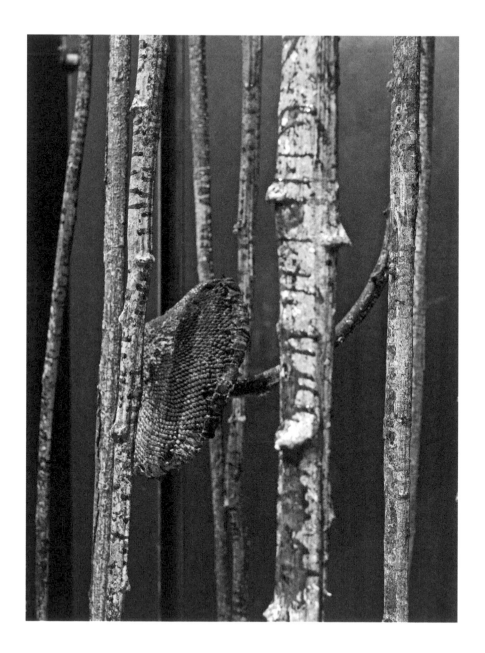

Kiefer

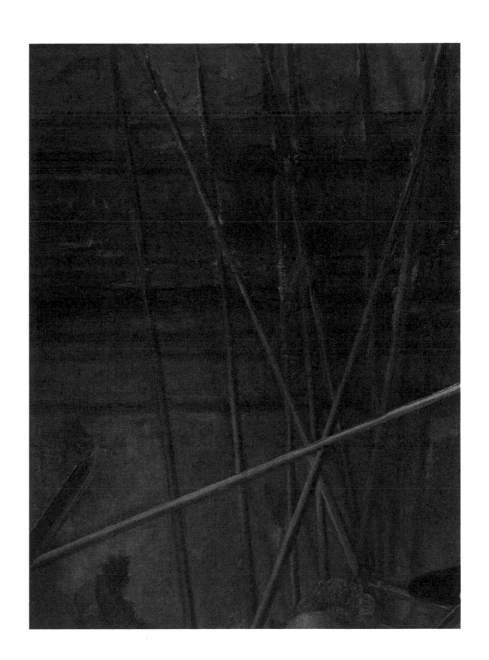

Rembrandt

an Farbe übrig bleibt, ist karg, wie das Graugelb und das fahle Grünbraun in einem frühen Bild wie *Märkische Heide*. Darin ist ein anderes Verschwinden das epische Motiv: das des geraden Sandwegs, der sich endlos entfernt und im Horizont auflöst. Da ich das Bild aus dem Jahr 1974 schon fast seit seiner Entstehung kenne, ist es für mich so charakteristisch geworden, dass ich bei den desolat hängenden toten Sonnenblumen in ihrer kalten Vitrine natürlich an die drei Birkenstämme in der immensen Verlassenheit jener ostdeutschen Landschaft dachte. In den Vitrinen hängen die meisten Sonnenblumen bis fast an den Lehmboden. Da ihre Farbe ein unbestimmtes Grau und Braun ist, verblasst gegenüber dem Dunkelgrün von früher, wird das Licht dort kühl und grau, als wäre die Vitrine ein vertikaler Sarg.

Dieses Werk ist also ein schweigsames Lamento. Ohne das laut lachende Gelb von Sonnenblumen in voller Blüte hat es den Ton einer stillen Trauer. Verschwunden ist die warme Umarmung der Farbe, die für van Gogh so trostreich war. Alles in dieser Szene ist jetzt still geworden, das Licht reglos und in Trauer. Eine Dämmerung hat sich herabgesenkt, so wie sich in Mondriaans kühlen Mondnächten Mühlen und Bäume dunkel gegen den bleichen Himmel abzeichnen.

Wenn es nicht zu leichtfertig wäre, würde man Kiefers *La Berceuse* mit diesem mageren Licht ein wahres Nachtstück nennen können. Jetzt stand es für eine Zeit gegenüber dem großen Gemälde von Rembrandt, das im Laufe der Jahre den Namen *Die Nachtwache* erhalten hat. Gedacht war es als Gruppenporträt der Amsterdamer Schützengilde von Hauptmann Frans Banninck Cocq und Leutnant Willem van Ruytenburgh, doch das ist es längst nicht mehr. Als *Die Nachtwache* wurde es, vorläufig zumindest, zum Nationalgemälde der Niederlande.[3] Es ist ein verehrungswürdiges, vorbildliches Werk. Der Maler Samuel van Hoogstraten betonte dies, als er in seinem verdienstvollen Buch *Inleyding tot de hoge schoole der schilderkonst* (Einführung in die Hohe Schule der Malerei; 1678) von der geschickten Anordnung der Figurengruppen sprach. *Den wahren Meistern gelingt es, dass ihr ganzes Bild eine große Einheit ist (...) Rembrandt hat dies in seiner Arbeit in den Doelen zu Amsterdam sehr wohl, aber nach mancher Leute Gefühl, allzu stark beherzigt (...) Jedoch wird eben diese Arbeit trotz des Tadelns all seinen Mitstreitern trotzen, da es so bildhaft in seiner Anlage, so schwungvoll und so kraftvoll ist, dass daneben nach Ansicht mancher Leute all die anderen Bilder dort in den Doelen-Werkstätten wie Kartenspielereien wirken. Doch ich hätte es besser gefunden, wenn er sie heller ausgeführt hätte.* Hoogstraten musste es wissen, denn er hatte als Rembrandts Schüler in dessen Atelier gearbeitet, als der Meister 1642 mit dem Bild beschäftigt war.

Inzwischen merkt das Rijksmuseum – wie andere ähnliche Museen auch –, welch Schwergewicht die Großen Meister in seiner Nationalen Schatzkammer darstellen. Es ist das Wesen der Kunst, dass niemals etwas für immer feststeht. Über Rembrandt kann man nicht immer dasselbe denken. Und so wird der Augenblick kommen, da wir genug haben beispielsweise von den van Goghschen Sentiments. Was *Die Nachtwache* betrifft: Dieses Gemälde hatte seine eigentliche Gültigkeit und Relevanz, als es entstand und, wie Hoogstraten es behutsam ausdrückt, die damalige Praxis (auf)störte. Es hatte eine respektlose, bemerkenswerte, neue Formulierung für das klassische Gruppenporträt gefunden – ein wichtiges Thema in den holländischen Städten, das jedoch wegen sensibler Formalitäten nur mühsam zum Leben erwachte. Wie eh und je ging es darum, wer vorne stehen durfte und wer darüber zu entscheiden hatte. Rembrandt hatte die Gruppe der Schützen

3 Vorläufig, denn irgendwann wird diese Position von Mondriaans *Victory Boogie Woogie* eingenommen werden.

4 Das Werk war damals gerade fertig geworden. Am Ende hatte der Meister es mit Hilfe seiner Assistenten, unter ihnen Giulio Romano, vollendet.

als einen Moment der *Bewegung* verstanden, einen eigenartigen ziellosen Augenblick, in dem der Hauptmann seinen Leutnant beauftragt, die Compagnie marschieren zu lassen. So wurde es zu dem, als das es später in einem Familienalbum der Banninck Cocqs beschrieben wurde; eine unverdächtige Quelle würde ich sagen, nüchtern und künstlerisch bedeutungslos (anders als Hoogstraten) und darum wahrscheinlich zuverlässig. Ich frage mich manchmal, ob nicht ein Mitglied der Familie selbst vom alten Rembrandt gehört haben kann, was er mit dem Gemälde beabsichtigte. Sie wohnten alle in Amsterdam. Banninck Cocq, auf dem Gemälde in vornehmem Schwarz mit roter Schärpe, macht eine gebieterische Gebärde. Der modisch gekleidete Leutnant schiebt demonstrativ seine Pike vor. Beide beginnen zu laufen. Danach zeigen die Bewegungen aller anderen Gestalten in ihrer ganzen Beweglichkeit, was nach einem solchen Befehl folgen *muss* – wie bei ruhigem Wetter die Zweige und Blätter einer Baumkrone durch einen plötzlichen Windstoß in lebhafte Bewegung kommen. Gemälde selbst bewegen sich nicht und machen kein Geräusch. Aber der Maler kann ein *Stadium* von Bewegung zeigen. Und das tat Rembrandt: Die Schützengruppe ist in verwirrter Aufregung, alle tun irgendetwas, während sie nach ihrem Platz im Glied suchen; und der Künstler und kein anderer entschied, wo schließlich jeder stand. Das war respektlos – aber was soll man machen, wenn man Historienmaler ist wie die bewunderten Rubens und Raffael. In gewissem Sinne ist *Die Nachtwache* denn auch ein Gruppenporträt, dessen frappante Mise en Scène mit dem Gedanken an etwas wie die *Transfiguration*, Raffaels letztes Meisterwerk, entstanden ist, deren unvergleichliche Komposition Rembrandt nur von den Drucken des Cornelis Cort kannte, denn in Rom war er nie gewesen.

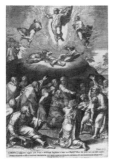

Cornelis Cort, *Die Verklärung Christi*, 1573. Kupferstich, 618 x 395 mm. Rijksmuseum, Amsterdam
Inv. Nr. RP-P-OB-7146

Seitdem in der europäischen Kultur das Bedürfnis empfunden wurde, mit Kunstwerken übersichtliche, realistisch geformte Geschichten zu erzählen, welche die Menschen mitreißen sollten, wurde es Aufgabe der Maler, Kompositionen in einem suggestiven Raum so zu entwickeln, dass sich die Figuren wie Schauspieler auf der Bühne überzeugend bewegen konnten. Es ging darum, ausdrucksvolle Haltungen und Gebärden zu erfinden und darum, wie diese in einem Gemälde effektiv zu kontrollieren waren. In diesem Sinne will ich zusammenfassen, was in der Renaissance und danach künstlerisch geschah. Als Raffael im April 1520 in seinem Atelier aufgebahrt lag, stand dieses Gemälde (im Deutschen auch *Die Verklärung Christi*) am Kopfende seines Sargs: Das letzte Beispiel, gleichsam als Erbe, seines unerreichten Erfindungsreichtums im Komponieren so genannter beweglicher Figuren.[4] Die beiden Geschichten, die ineinander übergehen (Mt 17, 1-22) werden auf dem Gemälde in zwei Ebenen ausgearbeitet. Oben sehen wir Jesus, der sich wundersam in eine göttliche Erscheinung verwandelt: (...) *sein Angesicht leuchtete wie die Sonne, seine Kleider aber wurden weiß wie das Licht.* Das ist schön. Aber das wirkliche Drama spielt sich während des Wunders der Verklärung unten am Berg ab, im Schatten, wo es den Jüngern nicht gelingt, einen mondsüchtigen Jungen von seinen Dämonen zu erlösen. Sie weisen mit dem Finger aufeinander, nach oben und auf den verwirrten Jungen in Begleitung seiner verzweifelten Eltern und anderer Verwandter. Sie sind sich nicht einig und vielleicht fangen sie gleich Streit miteinander an. Die Mise en Scène ist viel ereignisreicher, so scheint es, als das Geschehen, wie es in der einfachen Sprache des Evangeliums zu lesen ist. Und gerade diese Beweglichkeit der Gestalten fügt der Maler der Szene hinzu. Das macht er mit einer Geschicklichkeit, die so natürlich wirkt, dass sie kaum auffällt. Vergleichen wir beispielsweise von Gestalt zu Gestalt die großen Armgebärden der Gruppe auf der unteren Bildhälfte miteinander,

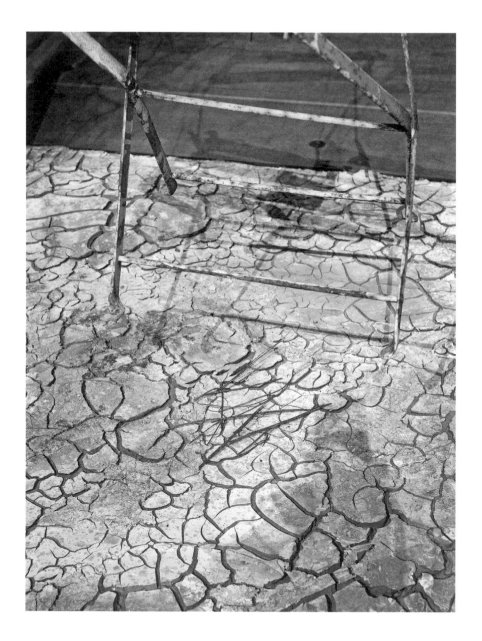

Kiefer

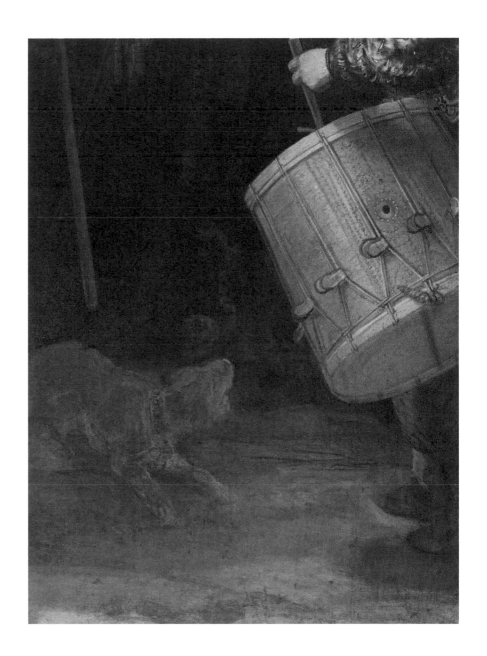

Rembrandt

scheinen sie symmetrisch zu sein, sind es aber nicht. Auch in der *Nachtwache* sehen wir solche Abweichungen im Reim, um es so auszudrücken: eine Art, lebendige Variationen zu introduzieren. Denn bei dieser Erzählweise soll immer auch der Eindruck erweckt werden, das Publikum sähe es vor den eigenen Augen geschehen. Wörtlich: Du könntest dabei sein. Raffaels Gemälde ist etwas über vier Meter hoch. Dadurch sind die Gestalten unten und im Vordergrund mehr oder weniger lebensgroß. Man könnte gleichsam zwischen ihnen herumschlendern und dann (in dem ausgetüftelten theatralischen Aufbau des Werks) von dort erstaunt nach oben blicken, wo sich das Wunder vollzieht. Auch *Die Nachtwache* ist so suggestiv. Sie ist etwas höher: Die horizontale Mittellinie verläuft ungefähr durch das Gesicht von Banninck Cocq, wodurch die Personen im Vordergrund lebensgroß sind. Natürlich hatte auch die Höhe, in der die Bilder hingen, Einfluss darauf, wie sehr der Betrachter sich in das hineinleben konnte, was er zu sehen bekam. *Die Nachtwache* hing nicht sehr hoch. Den Herren, die darauf abgebildet waren, konnte man sozusagen am nächsten Tag auf der Straße begegnen. Das erforderte einen gewissen Realismus vom Maler. Die Szene musste, zumal in dem protestantischen Holland von damals, ziemlich nüchtern und natürlich wiedergegeben werden – vor allem in der Breite, von Nahem und mit den auf dem Boden stehenden Schützen. Dass Rembrandt mehr Schwung in sein Bild brachte, fiel damals schon auf. Doch das war nichts im Vergleich zu Raffael. Die *Transfiguration* ist relativ schmal. In diesem schmalen Raum musste er im unteren Teil für dreizehn Protagonisten in der Hauptgruppe und noch einmal sechs Figuren hinter dem Vater des mondsüchtigen Jungen Platz finden. Im Theater würden sie anonym *Volk* heißen. Zugleich musste das Bild ziemlich hoch über einem Altartisch hängen. In der Konstruktion der Perspektive musste der Maler die leicht aufwärts gerichtete Sicht berücksichtigen. Das und die Menge der Gestalten auf kleinem Raum mussten Raffaels Bild zu einer meisterhaften Darstellung der ganz genau und schön ineinander verschlungenen Gruppe machen, brillant und verführerisch. Dazu kam in jener Zeit die Sucht nach einem eleganten Stil, der später *bella maniera* heißen würde. Mit diesem Bild hat die ästhetische Passion des Manierismus angefangen. Aber für diese Seite Meister Raffaels hatte der Holländer Rembrandt weniger Interesse.

Es wäre spektakulär, jedoch nicht befremdlich gewesen, hätte man im Rijksmuseum die *Transfiguration* gegenüber der *Nachtwache* aufgehängt. Beide Gemälde gehören nämlich in grosso modo noch demselben Kunstgebiet an, in dem sie einander jedenfalls nicht widersprechen. Sie malen erzählende Situationen, und zwar so, dass die in ihrem Verlauf vom Anfang bis zum Ende übersichtlich bleiben und nachzuvollziehen sind. Sie wetteifern miteinander. Nun aber steht Kiefers *La Berceuse* dort, eine extrem eigenwillige Version von van Goghs Bild. Die drei Vitrinen stehen direkt nebeneinander. Auf den Fotos, die ich von ihrer Aufstellung im Atelier gesehen habe, stehen sie ungefähr zwanzig Zentimeter voneinander entfernt, in den schmalen Saal der *Nachtwache* würde dies breitere Arrangement nicht recht passen. Direkt nebeneinander erscheinen die Vitrinen wie ein einziges Schauspiel in drei Teilen. Das Werk wirkt dadurch gedrungener und schwerer, als wenn die drei Vitrinen getrennt voneinander im Tageslicht stünden. Da die *Berceuse* sich im Museum der gedämpften Beleuchtung der *Nachtwache* unterwerfen muss, ist das Werk insgesamt dunkler. In den Vitrinen wird der Raum dämmerhaft. Dieser Dämmer ist außerdem hauptsächlich braun und ockerfarben. Auch deshalb musste ich an ein frühes Bild von Kiefer denken, *Mann im Wald*, aus dem Jahr 1971, sein erstes Bild, das ich von Nahem

kennenlernte, weil es in der Wohnung eines guten Freundes in Bern hing. Ein Mann tritt auf einer Lichtung im Wald nach vorn. In meiner Erinnerung kam er *aus* dem Wald zum Vorschein. Das wäre dramatischer und geheimnisvoller gewesen, mehr à la Wagner. Es ist ein junger Mann, priesterlich in langem weißem Hemd, der in seiner linken Hand einen brennenden Zweig wie eine Fackel hält. Die Bäume im Wald stehen dicht nebeneinander, kerzengerade, bis auf einige, die links im Vordergrund den Raum markieren. Sie sind gelbbraun mit einem roten Schimmer, als würde das Licht der Fackel von den Stämmen zurückgeworfen. Weiter drinnen im Wald wird es dunkel. Hieran musste ich denken, als ich Auge in Auge der *Berceuse* gegenüberstand, natürlich wegen der Farbe, aber auch wegen der stillen Einsamkeit dieses Mannes, vergleichbar diesem einsamen, hängenden Stuhl in der leeren Vitrine. Es hatte etwas Theatralisches. Manchmal erschien der Wald mit seinen Baumstämmen wie ein Bühnenbild, dann wieder sah ich hängende Stängel der Sonnenblumen wie die schlanke Begleitung des Stuhls in der Mitte und auch des unerklärlichen Verschwindens von Madame Roulin.

Mit einem Wort wie „theatralisch" muss man vorsichtig umgehen. Maler können empfindlich sein. Der *Mann im Wald* ähnelt jedoch der mageren Gestalt in langem Hemd, wie sie in früheren Zeiten an der Brandung der Nordsee mit beschwörenden Gesten *Aktionen* durchführte, fotografiert in Schwarz-Weiß. Diese Gestalt ist Anselm Kiefer selbst, Schüler von Joseph Beuys, der die Pose von Caspar David Friedrichs *Mönch am Meer* annimmt. Das geschah anstelle des Malens. So sah ich das Bild *Mann im Wald*, auch weil das Werk so trocken und sparsam gezeichnet und gemalt ist, als Ort einer *Performance*, mit dem Künstler selbst in der Hauptrolle. Das Spiel, in dem er auftritt, ist ganz und gar sein selbstgemachtes. Es ist kein Sujet aus dem gemeinsamen Schatz unserer Kultur. Worin Raffael und Rembrandt und auch van Gogh sich noch bewegten, davon hat Kiefer (und nicht nur er) jetzt Abstand genommen. Denn dieses Erbe hat, außer als wunderschöne historische Kuriosität, keine wirklich zeitgenössische Tragfähigkeit mehr. Gegenüber der Ordnung der *Nachtwache* wirkt deshalb *La Berceuse* so, wie sie dort steht, wie ein Änigma, auch aggressiv. Ich betrachte die bizarren Sonnenblumen, die sich so schön kräuseln (dekorative Lieblingsformen des Jugendstil), doch ich kann mich ihrer Schönheit nicht wirklich hingeben. Dafür ist die Mise en Scène zu streng, zu karg. Allerdings scheint mir jetzt das, was wir bei Rembrandt sehen, beweglicher als vorher, geradezu herausfordernd, so wirkt zum Beispiel das zwischen diesen steifen Männern aufleuchtende Mädchen wie eine Erscheinung aus einem Märchen. Vielleicht ist *La Berceuse* eigenwillig aggressiv, weil alles, was darin verwendet wird, *echt* ist: der geborstene Lehm, der Stuhl an dem Eisendraht, die verblühten Sonnenblumen, die alle zusammen ein unabdingbares *tableau mort* darstellen, strenger und unbeugsamer als *Die Nachtwache* und schwerfällig am Boden. In allen vergleichbaren Bildern weisen uns die Wendungen in der Komposition ungefähr den Weg, wie wir das, was im Bild geschieht, betrachten und begreifen können. Die strenge *Berceuse* dagegen zwingt uns und auch der *Nachtwache* eine Entscheidung ab. Wir können es so ausdrücken: Rembrandt schilderte, obwohl in außergewöhnlicher Formulierung, eine Szene, die auch außerhalb von ihm existierte. In Kiefers Werk sehen wir, viel strikter, nur das, was er selbst sieht. In all ihrer Fremdheit ist *La Berceuse* unverwechselbar zeitgenössisch. Das sehen wir, weil der Rembrandt gegenüber ein Meisterwerk aus einer unerreichbar fernen Vergangenheit ist. Schließlich begreife ich viel besser, worum es Anselm Kiefer in seinem beherrschten Spektakel wirklich geht.

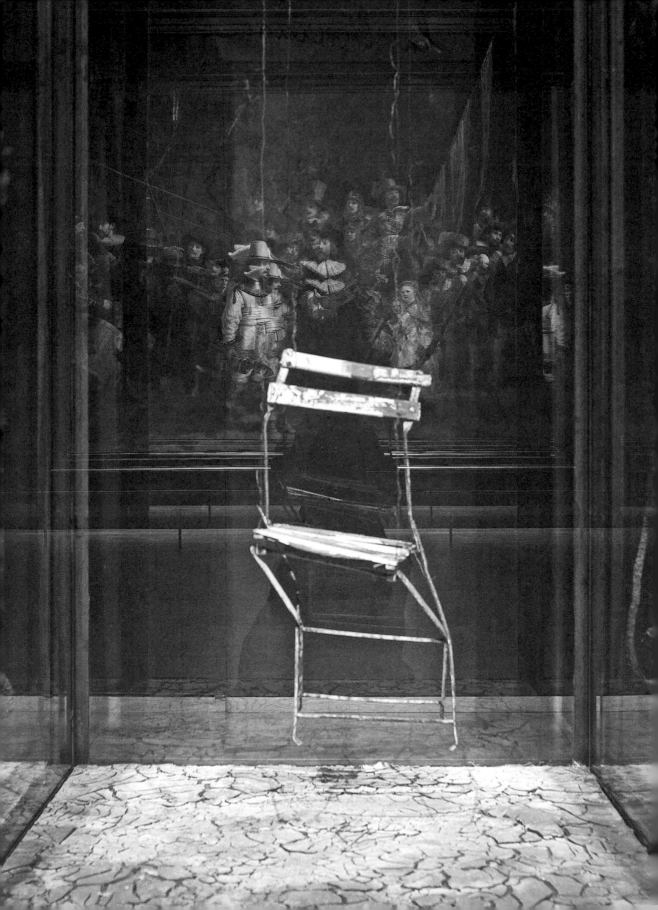

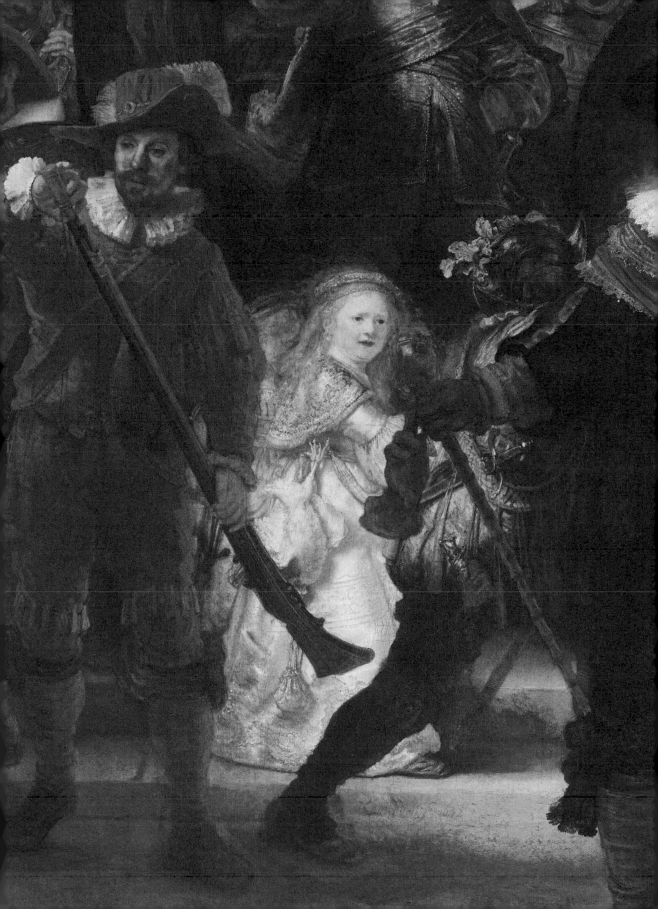

La Berceuse (2010), that is to say Anselm Kiefer's *mise en scène* which bears this title, is a dreamt sort of work. It is also strangely motionless. Because its sunflowers hang upside-down in such curls, like solidified tears, the whole inevitably comes across as a lament. That effect also arises because it is a reflection on another dreamt work, which Van Gogh contemplated and wrote about from Arles on 28 January 1889, to his brother Theo, but never hung on the wall. He had painted a portrait of Augustine Roulin, the wife of the village postman who had become his friend. Though he had been working on that painting when he fell ill, he explained in the letter, two versions of his *Berceuse* did exist already. On 21 January he had written to Paul Gauguin about his progress on the painting of Madame Roulin, whose hands were not finished yet, due to his accident. As one painter to another, he writes: *As an arrangement of colours: the reds moving through to pure oranges, intensifying even more in the flesh tones up to the chromes, passing into the pinks and marrying with the olive and Veronese greens. (...) And I believe that if one placed this canvas just as it is in a boat, even one of Icelandic fishermen, there would be some who would feel the lullaby in it.*[1] *Ah! my dear friend, to make of painting what the music of Berlioz and Wagner has been before us... a consolatory art for distressed hearts! (...) In my mental or nervous fever or madness, I don't know quite what to say or how to name it, my thoughts sailed over many seas. (...) and it seems that I sang then, (...) to be precise an old wet-nurse's song while thinking of what the cradle-rocker sang as she rocked the sailors and whom I had sought in an arrangement of colours before falling ill.* Those compositions of color are the famous sunflowers which, arranged in a vase and set against an intense and light background of pale blue-green or yellow, began to capture his interest during the summer, when they were in bloom.

During what he alternately refers to as his *illness* or *mental fever* or even *accident*, Vincent works on both *La Berceuse* and *Sunflowers in a Vase*.[2] In a certain way those two subjects begin to converge to such a degree that he arrived at the idea of combining them in a triptych. It was to become, he writes to Theo on 28 January, an unusually comforting picture so that *sailors, at once children and martyrs, seeing it in the cabin of a boat of Icelandic fishermen, would experience a feeling of being rocked, reminding them of their own lullabies.* This does express the gentle, melodious sentiment that sways to and fro in the paintings. In the letter to Gauguin, he also mentions that, while visiting the Roulins one evening, Roulin began to sing for his young daughter. His voice then *took on a strange timbre in which there was a hint of a woman rocking a cradle or a distressed wet-nurse, and then another sound of bronze, like a clarion from France.* In Arles, clearly, Van Gogh lived in great sadness. Perhaps the intense paintings were also meant, as company, to assuage his loneliness and to provide solace in that time of his own confusion.

Like music, the warmth of color was a curative balm. On 22 January 1889, he writes to his friend Arnold Koning about a vase with sunflowers: *Painted with the three chrome yellows, yellow ochre and Veronese green and nothing else.* Because the thick paint's expressiveness plays a role, the actual appearance of these colors is much brighter than words can say. In that same letter he refers to the *Berceuse*: *a woman dressed in green (bust olive green and the skirt pale Veronese green).* And then comes this: *Her hair is entirely orange and in plaits.* Due to the short, firm strokes with which both that combed hair and the wavy

1
They had read a new novel together: *Pêcheur d'Islande,* by Pierre Loti (Paris, 1886). As the fishermen sat in the cabin, dreamily gazing away at a devotional picture on the wall, they felt the quiet rocking of the sea that carried their ship and reminded them of being swayed to and fro by their mothers in childhood.

2
His mental condition was so unstable that he had cut off part of his right ear on the evening of 23 December 1888. Later that night, having declined into semi-unconsciousness due to blood loss, he was found by the postman Roulin and taken to the hospital.

flowers have been painted, their form seems to have equal substance and weight. This is what a painter sees happening in his works when, with the obsession of Vincent (who has reddish hair himself), he continues to observe until, suddenly, things start coming together. That's when, especially if you're a bit feverish, they begin moving and becoming restless. *A woman dressed in green with orange hair stands out against a green background with pink flowers*, he writes excitedly to Theo. (…) *I can imagine these canvases precisely between those of the sunflowers – which thus form standard lamps or candelabra at the sides, of the same size;* (…) What a masterly *mise en scène*: paintings that exude light.

In May 1889, during his stay at the hospital in Saint-Rémy, he hears of a possible opportunity to exhibit a few paintings in Paris. Why not finally show those, he writes to Theo. By this time he has, in fact, produced four *Berceuses* and even more paintings of sunflowers. In the letter he scrawls out a brief sketch of his idea. *You must know, too, that if you put them in this order: that is, the Berceuse in the middle and the two canvases of the sunflowers to the right and the left, this forms a sort of triptych. And then the yellow and orange tones of the head take on more brilliance through the proximity of the yellow shutters. And then you will understand (…) that my idea had been to make a decoration like one for the far end of a cabin on a ship, for example.* And a year or so later he died, so early in his difficult life that his entire body of work has become a sorrowful elegy.

Anselm Kiefer's version of *La Berceuse* consists of three separate, closely juxta-posed vitrines with metal joints and clear glass on all sides. Each measures 150 × 150 centimeters and has a height of about four meters. The floor of each vitrine has been covered with a layer of fired clay, sand-colored and cracked like dried earth. Suspended upside-down from the closed ceilings of the vitrines to the right and left are the gnarled stems of sunflowers, gone to seed; their blossoms curl whimsically upward due to the inversion. The sunflowers have been treated with resin that glistens a bit here and there. In the middle of the central vitrine a rusty folding metal chair, its paint flaking off, hangs from wire and is so crookedly bent that it seems to have given way beneath some weight. Written by Kiefer in dark pastel crayon across the front window of the middle vitrine, at mid height: *la berceuse*. This work's strange connection with the painting by Van Gogh should therefore be taken seriously. What first strikes us is the absence of the woman. A lightweight chair (different from the sturdy wooden chair, with curved armrests, in the painting) does remain. Like a swing, it hangs there in space at a slight angle, just above the barren earth. The longer I look the more it seems to be moving, almost imperceptibly, as if someone has just risen from it. In this work, and in its center, that is the narrative event. This is why the vitrines are so high: in order, literally, to heighten the space of that mysterious disappearance. Also vanished, faded and extinguished are the full, radiant colors that Van Gogh had planned to set alight (like lamps or candlesticks) in his triptych. That can be sensed more distinctly, I think, when you see the vitrines in the whitish lighting of the studio where they were made. In that light, which is also stark, the colors of the chair, sunflowers and dried clay tend toward greyish hues. What remains in that nearly monochromatic range of color is sparse, like the greyish yellow and the drab greenish brown in an early painting such as *Märkische Heide*. In this work another disappearance of the narrative motif can be seen: that of the straight dirt road which keeps on receding and dissolves on the horizon. Because I've

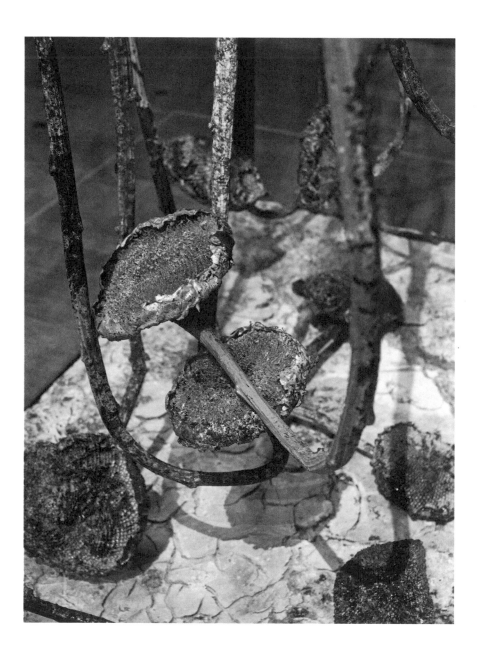

Kiefer

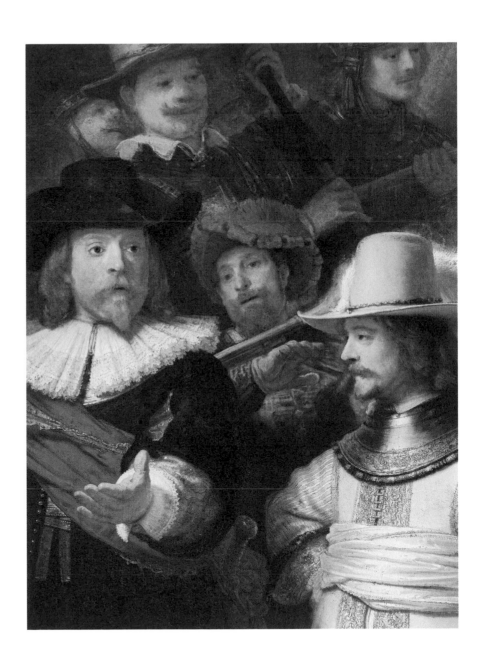

Rembrandt

known that painting from 1974 practically since its birth, it has become so characteristic that, on seeing the desolately hanging dead sunflowers in their cold vitrines, I naturally had to think of those three birch trunks in the immense desolation of an East German landscape. In the vitrines most of the sunflowers hang nearly down to the ground of clay. Because their color is vaguely grey and brown, having faded from the earlier dark green, the light in these glass cases becomes bleak and greyish, evoking the idea of a vertical coffin.

This work is therefore a silent lament. Without the loud yellow of sunflowers in blossom, its tone is one of quiet grief. Gone is the warm acceptance of color that was so consoling to Van Gogh. Everything in this scene has fallen silent now; the light, motionless, is in mourning. A twilight has descended upon it, as in Mondrian's cool moonlit scenes where the windmills and trees stand in darkness against a pallid sky.

If it weren't so frivolous, Kiefer's *La Berceuse* could, with its scantness of light, be called a veritable nocturnal work. Here it stood, temporarily installed, across from the large painting by Rembrandt which has become known as *The Night Watch*. This was intended as a group portrait of Amsterdam's civic guard led by Captain Frans Banninck Cocq and Lieutenant Willem van Ruytenburch, but it has ceased to be this for quite some time. As *The Night Watch* it has, at least for now, become the national painting of the Netherlands.[3] It is a commanding and exemplary work. In his distinguished book *Inleyding tot de hooge schoole der schilderkonst* (1678) the painter Samuel van Hoogstraten brought it up in connection with his discussion of the proper arrangement of groups of figures. *The true masters succeed in unifying their work entirely. Rembrandt has observed this requirement very well in his piece in the Doelen Hall in Amsterdam; though in the opinion of many he went too far, making more work of the overall picture, according to his preference, than of the individual portraits he was commissioned to do. Nonetheless, this painting, no matter how much it is criticized, will in my opinion survive all its rivals, because it is so picturelike in conception, so ingenious in the artful placement of the figures, and so powerful that according to some people, all the other paintings in the Doelen Hall look like playing cards alongside of it.* Hoogstraten was in a position to know this, having worked in Rembrandt's studio as a pupil, in 1642, while the master was occupied with the work.

Meanwhile today's Rijksmuseum, like other museums of its kind, has begun to sense the momentousness of the great Old Masters in its national treasury. The essence of art is that nothing remains etched in stone. We cannot keep on thinking the same way about Rembrandt. There also comes a time, for instance, when we've had enough of the sentiments of Van Gogh. As far as *The Night Watch* is concerned: that painting became truly valid and relevant only once it had been produced and thereby, as Hoogstraten cautiously points out, disrupted the current practice. It had arrived at a bold, remarkably new way of articulating the classical group portrait – an important theme in the cities of Holland, but one which nevertheless had difficulty in developing due to delicate formalities. As always, these revolved around the issue of which members of the group should be allowed to stand in front and who exactly should determine this. Rembrandt had conceived the group of militiamen as a moment of movement, a strangely aimless moment at which the captain orders his lieutenant to make the company

3
For the time being, since that position will one day be taken over by Mondrian's *Victory Boogie Woogie*.

4
The work had just been finished. In the end the master had completed the work with the help of his assistants, including Giulio Romano.

march. This is how it was later described in a family album belonging to the Banninck Cocqs; a source above suspicion, I would say, matter-of-fact and free of artistic concerns (unlike Hoogstraten) and therefore probably correct. Sometimes I wonder whether anyone from the family itself may have heard Rembrandt explain, in his later years, what his intentions were with the painting. All of them lived in Amsterdam. Banninck Cocq, wearing dignified black and a red sash in the painting, makes that commanding gesture. The fashionably dressed lieutenant thrusts his weapon demonstratively forward. The two set out to walk. After that, all of the movements of all those other figures show, in their liveliness, what should result from such an order – as on a calm day, when a sudden gust of wind makes the branches and leaves of treetops stir restlessly. Paintings themselves don't move, and they make no noise. But the painter can make a state of movement visible. That is what Rembrandt did: the group of militiamen, in confused turmoil, each one doing whatever comes to mind while seeking a position among the ranks, as no one other than the artist himself determined where they would stand. That was bold – but what else are you to do when, like the revered Rubens and Raphael, you're a history painter by nature? In a certain sense, *The Night Watch* is consequently a group portrait whose striking *mise en scène* has been designed with the general scheme of *La Trasfigurazione*, Raphael's final masterpiece, in mind. Rembrandt knew of this unparalleled composition only from engravings like those of Cornelis Cort, since he had never been to Rome.

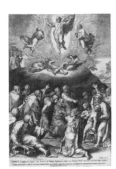

Cornelis Cort, *The Transfiguration*, 1573
Engraving, 618 x 395 mm
Rijksmuseum, Amsterdam
Inv. no. RP-P-OB-7146

As the need arose, in European culture, to employ artworks for the telling of comprehensible, realistically rendered stories that would involve people in the emotions of the narrative, it was important for painters to develop, in a suggestive space, compositions that were so fluid that the figures could move convincingly, like actors in a spectacle. This had to do with inventing expressive postures and gestures, and with how those were to be controlled as effectively as possible in a painting. Allow me to summarize what was going on, artistically speaking, in the Renaissance and thereafter. When Raphael lay in state in his studio in April 1520, this painting (known in English as *The Transfiguration*) was fittingly placed at the head of the casket: as a final example, as the legacy, of his unparalleled inventiveness in composing 'moving' figures.[4] The two stories that overlap each other (Matthew 17:1-22) have been developed on two levels in the painting. On the upper one, we see Jesus miraculously assuming a divine form: *and his face did shine as the sun, and his raiment was as white as the light.* That pleases the eye. But the real drama takes place during that miracle, at the bottom of the hill in the shadows, where apostles fail to free a moonstruck boy of his demons. They point to each other, upward and to the crazed boy who is accompanied by his despairing father and mother and other family. There is some difference of opinion, and perhaps they are starting to argue. This *mise en scène* is much more boisterous, it seems, than the way in which these events have been written in the plain language of the gospel. It is that very activeness of the figures which the painter has added to the scene. He has done so with tricks which appear so natural that we scarcely notice them. If we compare, in the lower half for example, the broad gestures of the arms with each other, from figure to figure, they do seem symmetrical but they are not. In *The Night Watch*, too, we see such deviations in rhyme, so to speak: that is a way of introducing lively variations. For this type of story-telling should create the impression, among the audience, that the tale is happening before its very eyes. Literally: you could

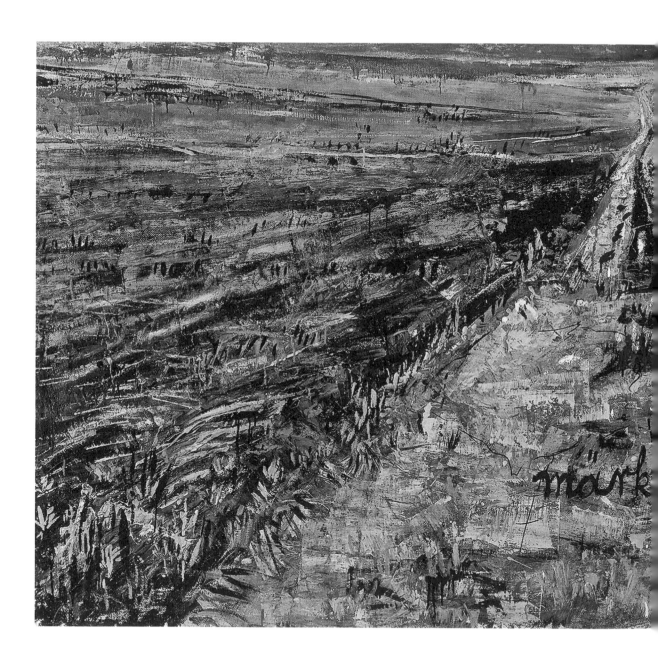

Anselm Kiefer
Märkische Heide, 1974
Öl, Acryl und Schellack auf Jute
118 × 254 cm
Van Abbemuseum, Eindhoven
Inv. Nr. 879

Anselm Kiefer
Märkische Heide, 1974
Oil, acrylic and shellac on jute
118 × 254 cm
Van Abbemuseum, Eindhoven
Inv. no. 879

be there. Raphael's painting is just over four meters in height. This means that the figures at the bottom and in the foreground are more or less life-size. So it would be possible for us to stroll among them and then (within the work's cunning theatrical construction) look up in astonishment from there at the miracle taking place above. *The Night Watch*, too, has this suggestive power. It has a slightly greater height: its horizontal middle line runs roughly through the face of Banninck Cocq, which makes the characters in the foreground large as life. Of course the height at which the paintings were hung also influenced the extent to which the viewer could empathize with what he was seeing. *The Night Watch* was not hung especially high. The gentlemen depicted in it could, in a manner of speaking, be encountered on the street the next day. That put certain demands, in terms of realism, on the painter. The scene had to be rendered, already in the Protestant Holland of that time, in a fairly plain and natural way – broadly especially, from a close perspective and with the militiamen on the ground. The fact that Rembrandt had added a certain verve to his painting already drew attention then. But that was nothing compared to Raphael. *The Transfiguration* is relatively narrow. In that narrow space he had to find room, in the lowest part, for thirteen protagonists in the main group and another six figures behind the father of the moonstruck boy. In a theatrical context, they would be referred to anonymously as 'people'. At the same time, the work was to hang fairly high above an altar. The painter had to take into account that the manner of viewing would be slightly upward. That aspect, as well as the crowding of many figures into a small space, meant that Raphael's painting would have to be brilliant and seductive, a masterpiece of meticulously and splendidly woven groups. Added to it was that period's desire for elegant style, which later became known as *bella maniera*. The aesthetic passion of Mannerism began with this painting. But that facet of the great master Raphael was of less concern to the Dutchman Rembrandt.

It would have been spectacular, but not strange, if *The Transfiguration* had been hung across from *The Night Watch* at the Rijksmuseum. Both paintings are, in fact, situated in roughly the same context of art, where they do not contradict each other in any case. They portray narrative contexts, in such a way that these remain clear and can be understood from beginning to end. They rival each other. Now, however, we see it with Kiefer's *La Berceuse*, his own thoroughly headstrong version of the painting by Van Gogh. The three vitrines stand side by side. In photographs showing their arrangement in the studio, they've been placed about twenty centimeters apart; that broader set up would not fit very well in the narrow gallery of *The Night Watch*. When placed side by side, the three vitrines seem to be a single spectacle, in compartments. The work thereby seems more compact and heavy than if the vitrines were standing separately in daylight. Because *La Berceuse* must be subject to the museum's subdued lighting for *The Night Watch*, the object has become darker. In the vitrines the space becomes shadowy. That twilight is moreover chiefly brown and ochre in color. This is also why I had to think of an early painting by Kiefer, *Mann im Wald* from 1971, the first painting of his that I became acquainted with more closely, since it was hanging in the home of a good friend in Bern. Here a man appears at a clearing in the woods. In my memory he was emerging from the woods. That would have been more dramatic and mysterious, more in the manner of Wagner. It is a young man, dressed in a priestly long white gown and holding a burning branch, like a torch, in his left hand. The trees in the woods stand

straight, densely grouped, with the exception of a few that mark the space in the foreground. They are yellowish brown, with a tinge of red, as though the flames are reflecting against the tree trunks. Further back into the woods, it gets darker. Standing face to face with *La Berceuse*, I had to think of this – partly due to the color, of course, but also because of the quiet solitude of that man in comparison to that lonely suspended chair in the empty vitrine. It was theatrical. Sometimes the forest of tree trunks seemed like a stage set, and then again I saw the hanging stalks of sunflowers as the slender accompaniment to the chair in the middle and to the inexplicable disappearance of Madame Roulin.

You have to be careful with a word like 'theatrical'. Sometimes painters are touchy. Yet this 'Man in the Forest' resembles the lean figure in a long gown, who in the early days carried out *aktionen* along the coast of the North Sea, with his arms in a gesture of invocation, and who was photographed in black-and-white. That figure is Anselm Kiefer himself, a pupil of Joseph Beuys, adopting the pose of the figure in Caspar David Friedrich's *Mönch am Meer*. His *aktion* took the place of painting. That's how I perceived *Mann im Wald*, also because the work has been drawn and painted so dryly and sparingly, as a performance site where the artist himself plays the lead role. The play in which he performs is entirely of his own making. This is no subject from a shared treasure in our culture. From that legacy, in which Raphael and Rembrandt and even Van Gogh still actively participated, Kiefer (and not just he alone) has now removed himself. Despite having significance as an extraordinarily beautiful historical curiosity, it has no real contemporary power any longer. As opposed to the orderliness of *The Night Watch*, the effect of *La Berceuse*, standing there as an enigma, is moreover one of aggression. I look at the lovely curls of the whimsical sunflowers (preferred decorative forms in Art Nouveau), but I can't really surrender to their beauty. The *mise en scène* is too severe and frugal for this. What I do get is the sense that what we see in the Rembrandt has become more agile than it had been before, almost frivolous, with that luminous girl appearing among those stately men as if she were in a fairy tale. Perhaps *La Berceuse* is obstinately aggressive because everything used in it is real: the cracked clay, the chair, the wire, the withered sunflowers which collectively suggest an inescapable *tableau mort*, more stern and inflexible than *The Night Watch* and standing bluntly on the floor. As in all such paintings, the twists in the composition point the way to occurrences that we can then observe and understand in the image. On the other hand, this stern *Berceuse* literally puts us, and *The Night Watch* too, on the spot. Let us say that Rembrandt painted a scene which, though exceptional in terms of articulation, did exist beyond himself. In the work of Kiefer we see, much more strictly, only that which he sees. In all its peculiarity, *La Berceuse* remains inexorably contemporary. We see that because the Rembrandt facing it proves to be a masterpiece from a distant past, far beyond our reach. Ultimately I understand the ambition in Kiefer's composed spectacle much better.

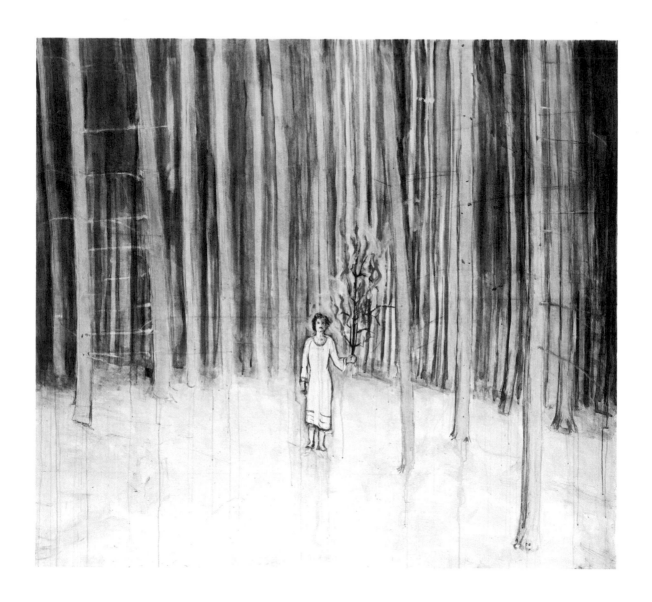

Anselm Kiefer
Mann im Wald, 1971
Acryl auf Nessel
174 x 189 cm
Privatsammlung

Anselm Kiefer
Mann im Wald, 1971
Acrylic on muslin
174 x 189 cm
Private collection

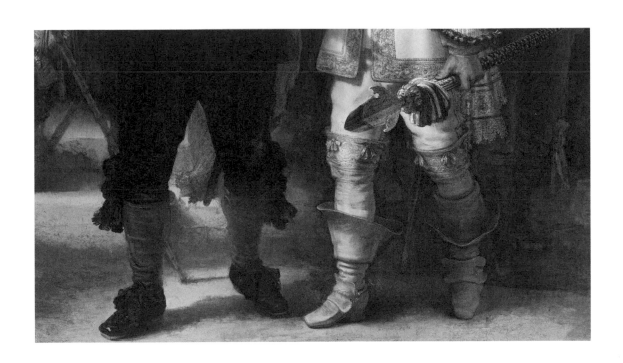

Rembrandt

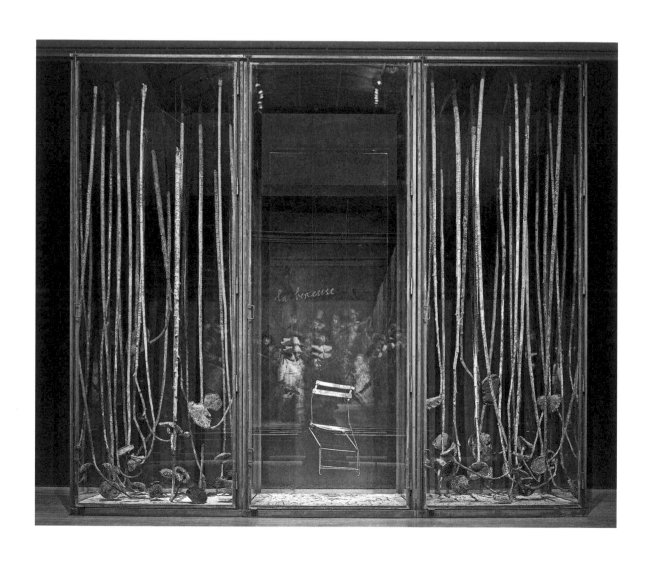

Anselm Kiefer
La Berceuse (Van Gogh), 2011
Harz, Eisen, Lehm und Glas
ca. 400 X 450 X 150 cm
Sammlung Anselm Kiefer

Anselm Kiefer
La Berceuse (Van Gogh), 2011
Resin, metal, clay and glass
c. 400 X 450 X 150 cm
Collection Anselm Kiefer

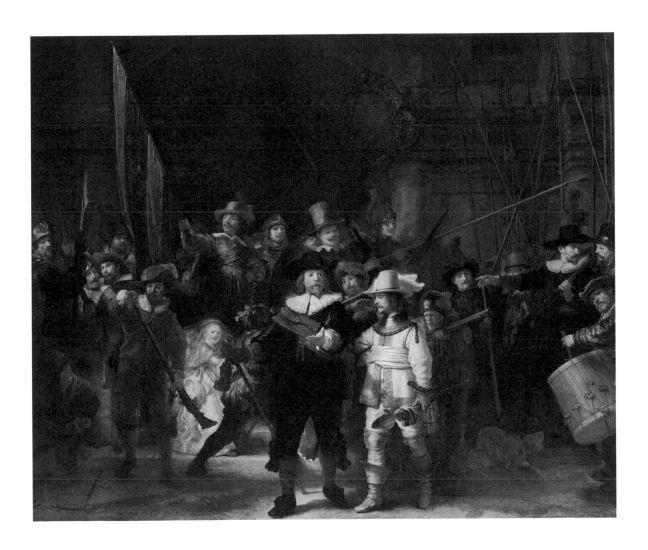

Rembrandt Harmensz van Rijn, *Offiziere und andere Schützen von Bezirk II in Amsterdam unter Führung von Hauptmann Frans Banninck Cocq und Leutnant Willem van Ruytenburch, bekannt als 'Die Nachtwache'*, 1642
Öl auf Leinwand, 379,5 × 453,5 cm
Rijksmuseum, Amsterdam
Inv. Nr. SK-C-5
Leihgabe der Gemeinde Amsterdam

Rembrandt Harmensz van Rijn, *Officers and Other Civic Guardsmen of the IInd District of Amsterdam, under the Command of Captain Frans Banninck Cocq and Lieutenant Willem van Ruytenburch, known as 'The Night Watch'*, 1642
Oil on canvas, 379.5 × 453.5 cm
Rijksmuseum, Amsterdam
Inv. no. SK-C-5
On loan from the City of Amsterdam

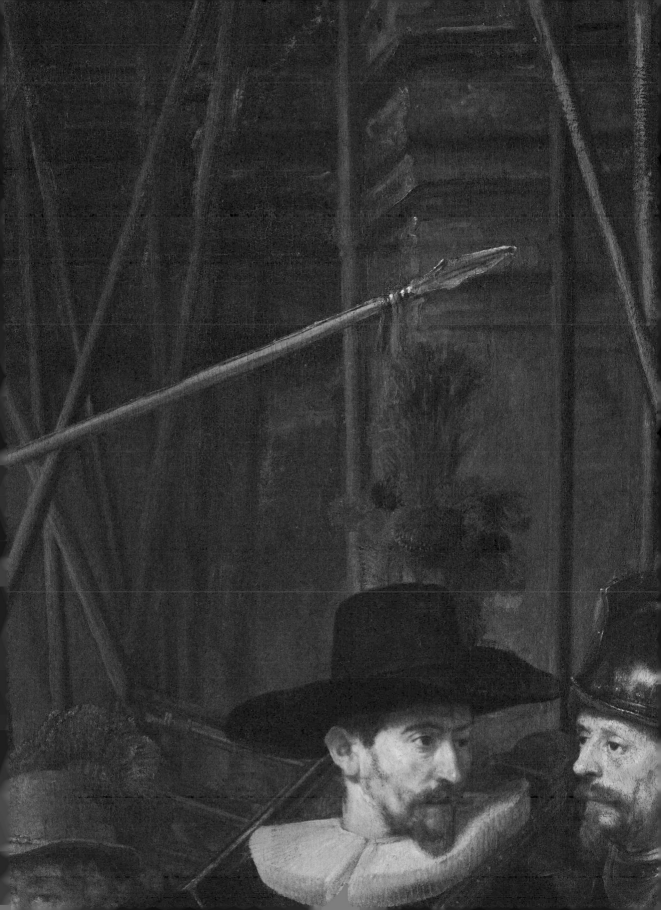

Diese Ausgabe erschien anlässlich der Ausstellung
This book has been published in connection with the exhibition

Kiefer & Rembrandt
Rijksmuseum, Amsterdam
7. Mai – 4. Juli 2011
7 May – 4 July 2011

Erschienen im Published by
Hirmer Verlag
Nymphenburger Straße 84
80636 München

In Zusammenarbeit mit In cooperation with
Rijksmuseum, Amsterdam

Unser besonderer Dank gilt White Cube, London, für einen
wichtigen finanziellen Beitrag zu dieser Publikation.
We should like to express our gratitude to White Cube, London,
for a significant financial contribution to this publication.

Autor Author
Rudi Fuchs, Amsterdam

Übersetzung Translation
Deutsche Übersetzung: **Marianne Holberg, Berlin**
English translation: **Beth O'Brien, Eindhoven**

Fotografie Photography
John Stoel, Haren (*La Berceuse*)
Rijksmuseum Image Department
Van Abbemuseum

Gestaltung Design
Irma Boom, Amsterdam

Lithographie Lithography
Reproline Mediateam GmbH,
Unterföhring

Druck Printing
Editoriale Bortolazzi-Stei S.r.l., Verona

Bindung Binding
Boekbinderij Patist BV, Den Dolder

Papier Paper
Munken Polar 150g/m2

Gedruckt in Italien
Printed in Italy

Die Briefe Vincent van Goghs an seinen Bruder Theo sind
folgender Ausgabe entnommen: *Als Mensch unter Menschen,*
Vincent van Gogh in seinen Briefen an den Bruder Theo,
Henschelverlag Berlin (DDR): 1959.
The quotations from letters by and to Van Gogh have been taken
from *Vincent van Gogh – The Letters. The Complete Illustrated*
and Annotated Edition. See www.vangoghletters.org/vg

Bibliografische Information der Deutschen Nationalbibliothek
Die Deutsche Nationalbibliothek verzeichnet diese Publikation
in der Deutschen Nationalbibliografie; detaillierte bibliografische
Daten sind im Internet über http://dnb.d-nb.de abrufbar.
Bibliographic information published by the Deutsche Nationalbibliothek
The Deutsche Nationalbibliothek lists this publication in the Deutsche
Nationalbibliografie; detailed bibliographic data are available in the
Internet at http://dnb.d-nb.de.

ISBN 978-3-7774-3831-3

© 2011 Hirmer Verlag GmbH, München;
Rijksmuseum, Amsterdam; Rudi Fuchs

www.hirmerverlag.de
www.hirmerpublishers.com
www.rijksmuseum.nl

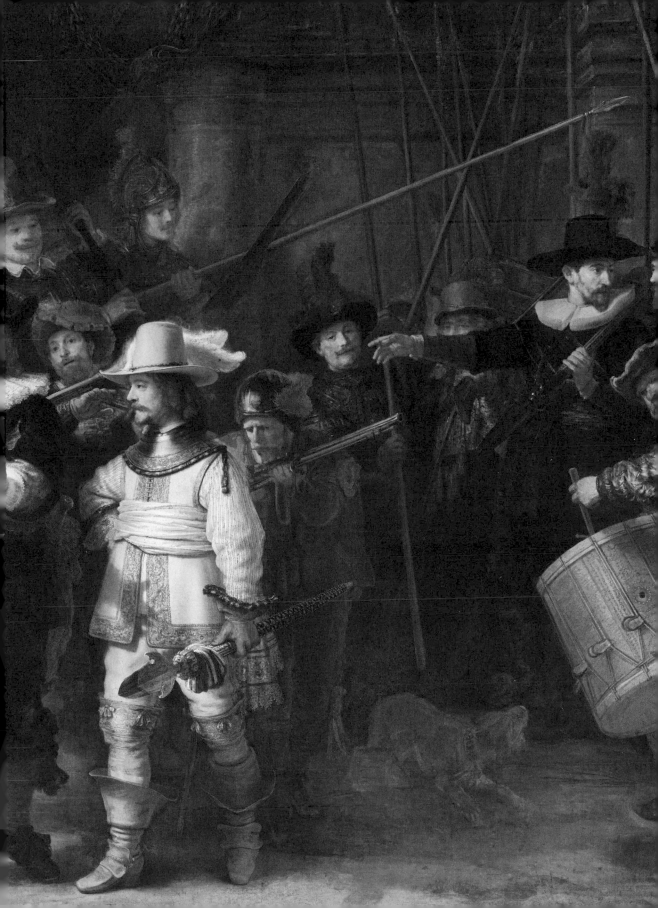

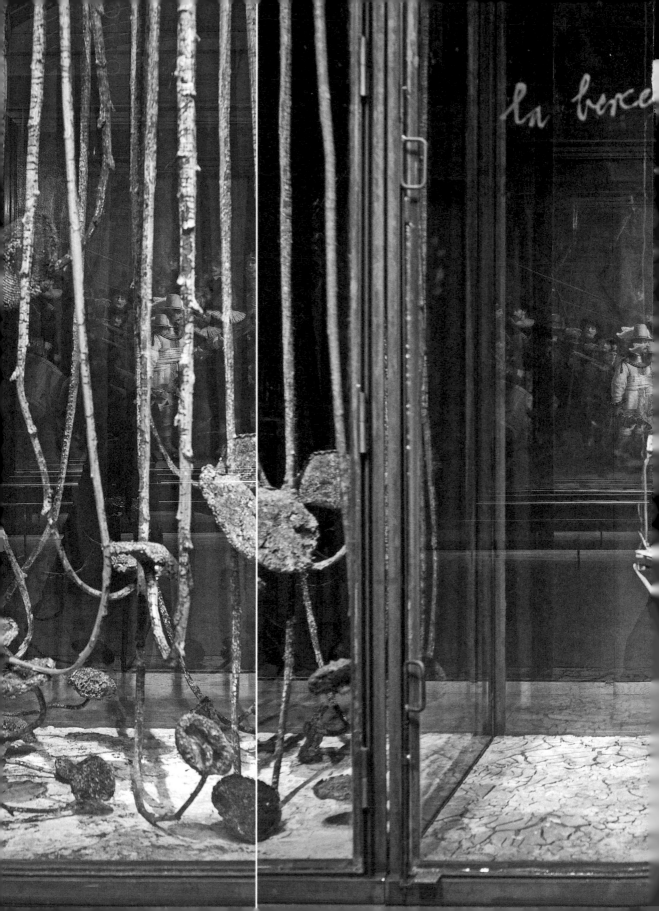